# 51

# WAYS

# TO EAT

# COCK:

## HEALTHY CHICKEN RECIPES TO EAT YOUR COCK RIGHT

By

Stella Bruce

&

Natalie Stevens

ISBN: 978-1-950284-87-0

**ISBN: 978-1-950284-87-0**

## Disclaimer

Please note, the information contained in this book, are for educational purposes only. Every attempt has been made to provide accurate, up to date and reliable complete information. By reading this document, the reader agrees that under no circumstances are we responsible for any losses, direct or indirect, which are incurred as a result of the use of the information contained in this document, including but not limited to errors, omissions or inaccuracies.

# Table of Contents

# <u>INTRODUCTION</u>

I dare say that there are basically three ways to do anything including preparing and eating your meals. Regardless of what methods, processes, procedures, and styles anyone propounds, all are categorized into just three, no more. There are (1) the right way, (2) the wrong way, and (3) *your* way.

Never mind 'em. Your way is the most important of the three even if anyone feels it is not the right way or someone else feels it's a wrong one. Of all the foods available to us, which one makes us feel more like adults? Yeah, I'm talking about the flesh, okay the meat. Of course, I am here positing that there are many meats for all ages and I will show you in this Book.

But I'm talking about the best of those meats. You gat it! My, it's the cock. Remember the last time you ate the cock? How does it make you feel each time you dare step up to the upscale and brazen out with this tough cut? What is your tongue telling you as you savor its pleasantness? Oh! It should be your nostrils that start communicating with you. Or is it your eyes that ignite the passion?

At any rate, if you do it *your own way,* you'll have a lot of love for the meal. Even before you get down and have the fun with your food, you're already having the romantic sensation with what's on your plate if *your way* is the correct way. That evening meal will take you to paradise if you're dining with the loved ones.

Go bizarre, express yourself and f*ck the hell out of the chicken. This book is the aid you need to do so. I have provided as much as 51 chicken recipes here that you can try your hands with, all year round. As you will see, the motive of this book is basically to provide the readers with something outside the realm of the ordinary when you are dealing with chickens.

However, efforts have been made to avoid recklessness in throwing ingredients together. As fanciful and extra-ordinary the recipes are, they are still within the health scope. A good number of them are actually gluten-free by the industry standard. Thus, everyone can find recipes designed just for him or her in spite of any general dietary restrictions.

To help you locate your choice recipes with all ease, the 51 recipes in this book have been segmented into 7 namely, soups and sauces, sandwiches, salads, pastas, rice and noodles, main dishes, and dinner. But I need to quickly add that there is nothing hard and fast about the segmentation. Don't forget; your way is the ultimate here. Those dinners can make your own breakfast, soups and sauce can be your own main course.

Set the ball rolling and hone your culinary experiences.

Bon appétit!

# CHAPTER 1: COCK SOUPS AND SAUCES

### Cock Soup

Let's start with something as spicy as this Jamaican soup. And this version of the soup adds the lovers' fun to your meal as well arouses envious feeling in anyone observing your good time while having the meal. The modest soup, which makes the best of use vegetables and roasted chicken, can go all the way alone or be the accompaniment for anything.

**Total cook time:** 1 hour 20 minutes.

*Ingredients*

- 1 cup browned chicken (chopped)
- 2 tbsps. olive oil (or brown butter)
- 1 bone carcass of cooked chicken
- 6 cups water
- 1 package green beans
- 2 tbsps. tomato sauce
- 1/3 red onion (to be sliced)
- ½ cup diced broccoli
- ½ cup diced mushrooms
- 1 package cock soup
- ½ cup thin chicken noodles
- Pimiento (to taste)
- Oregano (to taste)
- Pepper (to taste)
- One or two cloves garlic (to taste, optional)

## Instructions

1. Over medium heat, warm up the olive oil in a large soup pan.
2. Add onion, broccoli, two garlic cloves (if using), green beans, and mushrooms. Allow it to cook for four minutes or until all side is browned, tossing it gently with a wooden spoon.
3. Add tomato sauce, seasoning, and browned chicken.
4. Add water and keep stirring gradually in the soup. Then, mix in noodles.
5. Add chicken carcass. (Remove before serving.)
6. Adds flavor and fat.
7. Wait 30 minutes to simmer and keep on low heat for ten minutes.
8. Your cock soup is yummy. Enjoy.

**Yield**: 4 servings.

**Nutritional content per serving:** Fat: 8.7 g, Carbs: 7.3 g, Fiber: 3 g, Protein: 27.7 g.

## Easy Homemade Chicken Soup

The soupy folks will love this book, right? We are doing justice to the soup right now, especially the one made of cock. When pumpkin, carrot, garlic, berries, and pepper combine to make a soup at home, you can call the bluff of the sh*t for which the dick heads charge you hundreds of dollars plus various tips when you eat out.

**Total cook time:** 1 hour 15 minutes.

**Ingredients**

1 lb. chicken

¼ cup white cane vinegar

1 lb. pumpkin
1 medium carrot
2 cloves garlic
1 ½ cups counter flour
4 ½ cups water
1/8 tsp. salt
2 medium Irish potatoes
1 lb. yellow yam
1 packet cock soup mix (like Grace)
1 stalk scallion
1 sprig thyme
1½ tsps. salt
6 whole pimento berries
1 whole scotch bonnet pepper

## Instructions

1. Thoroughly clean chicken using about 4 cups of vinegar and water solution and then cut into bite-size pieces.
2. Peel pumpkin and carrot, dice the carrot and crush the garlic.
3. Bring water to boil in a medium-sized pot and add chicken, pumpkin, diced carrot, and garlic. Allow it to boil for about 40 minutes.
4. Mix flour, salt, and water in a pot until well combined. Then knead to make a smooth dough. Cover it and set aside.
5. Peel potatoes and yam and cut in bite-size pieces. Then pour to the boiling soup.
6. Divide the dough into six and make spinners with it.
7. Add the spinners to the soup.

8. Stir in the cock soup mix with the scallion into the soup together with thyme, pimento berries, pepper, and salt. Stir the mixture to mix well, cover it and allow about 15 minutes for it to simmer.
9. It's a fair suck of the sav.

*Yield:* 5 servings.

***Nutritional content per serving:*** Fat: 9 g, Carbs: 51.3 g, Fiber: 4 g. Protein: 20.7 g.

## Cock-A-Leekie

This Scottish soup made of chicken and leek has a lot of varieties. The extent of its recipes can't be exhausted. Yet, it finds its way down here to this recipe book so that you can f*ck with the cock while the aroma of leek takes the center stage. You will get about the same result if you use your own variety. Yours is the right way!

**Total cook time:** 1 hour 20 minutes.

***Ingredients***
- 5 lbs. whole chicken
- 4 leeks
- 2 garlic cloves (to be peeled and finely chopped)
- A handful of thyme
- Medjool dates (to taste)
- 1 lemon
- Sea salt (to taste)
- Pepper (Freshly ground)
- 1 cup water

## Instructions

1. Preheat the oven to 400°F. Meanwhile, unwrap the chicken and scoop out the giblets. Then leave to come to room temperature.
2. Cut the leeks in halves and rinse thoroughly to remove any grit, also cut the dates in halves and discard the stones. Sprinkle the leeks, garlic, and dates in a casserole dish or a roasting dish that can be covered with foil. Arrange the chicken on top of the leeks and add seasonings to taste.
3. Cut the lemon into halves and tuck one half together with half the thyme sprigs cavity into the cavity of your cock. If you want it richer, you can add the neck.
4. Pour water into the dish, put the lid on it. You may also cover with a double layer of foil.
5. Roast for an hour. Remove the lid or foil and allow it roast for 20 to 30 minutes more or until brown at the top. Pierce the thickest part of the thigh and examine the dripping juice to be sure that it's clear without any pink. If necessary roast for a few more minutes.
6. Set the chicken on a board and loosely cover with foil to allow it cool. Then serve.
7. Add the zest and the juice from lemon half before serving. Add the remaining lemon and leaves.
8. Serve while aromatic with broth in spoonfuls.

**Yield:** 4 servings.

**Nutritional content per serving:** Fat: 7.9 g, Carbs: 52.2 g, Fiber: 3 g. Protein: 28.7g.

## Chicken Curry With Tomatoes

This is one of the Indian styles of creatively feeding the cock and on the cock with curry while the two will enjoy some cooperation inside a diner at home. With the support of tomatoes, you can savor the healthy taste of this curry now. If you refrigerate the leftover curry for 8 hours or better still, overnight, you will see the best of the flavors that can be produced by this cock recipe!

**Total cook time:** 1 hour 10minutes
*Ingredients*
- 2 large onions (to be peeled, chopped)
- 1 tbsp. grapeseed oil
- 3 cloves garlic (to be peeled, chopped)
- 1-2 red chilies (to be deseeded, chopped)
- A thumb-size piece fresh ginger (to be peeled, chopped)
- 2 tsps. ground coriander
- 1 tsp. ground cumin
- 1 tsp. ground turmeric
- 1 tsp. garam masala
- 2 large ripe tomatoes (about 7 oz., chopped)
- 2 tbsps. tomato puree
- 2-3 cloves
- 1 cinnamon stick
- 3-4 cardamom pods
- 1 cup water

- 1 lb. chicken thighs (boneless, skinless, to cut into 1-inch cubes)
- 2 tbsps. natural yogurt
- Salt (to taste)
- Pepper (to taste)

## Instructions

1. Pour the oil into a non-stick pan over medium heat. Add onions to the hot oil and sauté for about 10 minutes or until soft and browned.
2. Add the garlic, chili, coriander, cumin, garam masala, ginger, and turmeric. Then continue sautéing for a couple of minutes more until fragrant.
3. Stir in the tomatoes, cloves, tomato puree, cardamom, cinnamon, and water. Cook for about 10 more minutes over medium-low heat while stirring occasionally.
4. Add the chicken and cover. Cook for 25 minutes more while stirring occasionally until the chicken is tender and cooked through all the way. Add more water if the curry is a bit dry.
5. Remove from heat, and then stir in the yogurt.
6. Season with salt and pepper and serve with rice or naan.

**Yield:** 4 servings

Nutritional content per serving: Fat: 7.5g, Carbs: 14.4g, Protein: 27.3g, Fiber: 4.6g.

# Chicken Satay With Peanut Dipping Sauce

What if you'd like to baptize your cock in the marinade and coat it in a sauce? Your friends will assume your honeymoon was held somewhere in Southeast Asian. This recipe book has made the Asian journey for you and hereby provides you with a recipe book that tantalizes couples. Don't spend that money on the ticket to Malaysia or Indonesia, your favorite Satay is quite easy to make at home.

**Total cook time:** 30 minutes.

*Ingredients*

- 1 lb. chicken thighs (skinless and boneless to be cut into 1-inch cubes)
- 1 tbsp. grapeseed oil

*Ingredients for Marinade*

- 1 stalk of lemongrass (to be roughly chopped)
- A thumb-sized piece fresh ginger (to roughly chopped)
- 1 tsp. ground turmeric
- 1 tsp. cumin seeds (to be toasted)
- 1 tsp. coriander seeds (to be toasted)
- 1 garlic clove (to be peeled and crushed)
- 1 tsp. lime (or lemon rind)
- 1 tsp. sugar
- 1 tsp. soy sauce
- 1 tbsp. water
- ½ tbsp. grapeseed oil

*Ingredients for Dipping Sauce*

- 1-2 tsp. red chili paste (or to taste)

- ½ cup coconut milk
- 1/3 cup water
- 1/2-1 tbsp. brown sugar (or to taste)
- 1-2 tsp. fish sauce (or to taste)
- 3 tbsps. peanut butter
- A squeeze of lime juice

### Instructions

1. Grind all the marinade ingredients with pestle and mortar until they combine thoroughly and form a paste.
2. Pour the paste over chicken and allow it to marinate for no less than 1 hour. (Better if left overnight).
3. Soak about 25 bamboo sticks in water for about 30 minutes.
4. Meanwhile, start to make the dipping sauce by sautéing the chili paste for 3 minutes in a small pan over medium heat. Stir in the coconut milk, sugar, and water. Bring to the boil and then allow to simmer for about 5 minutes.
5. Stir in the peanut butter and cook again for 5 minutes. Add the fish sauce and lime juice. Take it off the heat to be set aside.
6. Skew the cock onto the bamboo sticks and heat a non-stick skillet or a griddle pan on medium. Brush the cock skewers with oil and cook the cock for 12-15 minutes while turning occasionally until lightly browned and cooked through all the way.
7. Serve hot with the baptism of sauce.

*Yield:* 4 servings.

**Nutritional content per serving:** Fat: 8.38g, Carbs: 2.98g, Protein: 8.38g, Fiber: 1.0g.

## Cock O' The North

This is yet another baked fried chicken recipe that also has a gravy sauce. Perfectly served with mashed potatoes and corn, it's another way to eat your cock romantically.

**Total cook time:** 35 minutes.

### *Ingredients*

- 3 tbsps. flour
- 2 tbsps. vegetable oil
- 2 tbsps. margarine
- ¾ cup sour cream
- 1 ½ cups breadcrumbs
- 2 egg whites
- 10 ½ oz. cream of chicken soup
- 1 dash pepper
- 1 tsp. salt (to taste)
- ½ cup flour
- Pepper (to taste)
- 4 chicken breasts
- ½ lb. sliced mushrooms
- Water

### *Instructions* (for chicken)

1. Mix thoroughly flour, salt, and pepper until well combined. Roll the breasts in flour mixture, egg whites, then in bread crumbs one after the other.
2. Melt margarine and oil together in a skillet and add chicken to fry until golden brown on both sides.
3. Bake chicken at 400° F. Uncover until it's cooked through. (You may cover with foil to prevent it from burning if the breasts are browning faster than they're cooking in the middle).

### *Instructions* (for sauce)

4. In the same skillet used in browning the breasts, use the drippings to sauté the mushrooms for about 5 minutes. Add flour and then cook and stir until smooth.
5. Add soup and stir with enough water to allow the consistency of gravy. Boil it to the desired consistency and thickness
6. Add salt and pepper to taste.
7. Add sour cream and boil again for a minute.
8. Welcome to the north; serve the gravy over mashed potatoes with chicken.

*Yield:* 4 servings.

**Nutritional content per serving:** Fat: 16g, Carbs: 6g, Protein: 23g, Fiber: 1g.

# CHAPTER 2: COCK SANDWICHES

## Chicken and Scallops

This can be the main course for anyone and can wow your family, lovers, and your company. Your cock will taste paradisiacal and you and your guests will always take a bow on the after each meal. The subtle introduction of tarragon flavor in the creamy sauce brings the best out of the mushrooms, chicken, and scallops in a superlative way.

**Total cook time: 35 minutes.**

### *Ingredients*

- ½ cup all-purpose flour
- ½ tsp. salt
- ½ tsp. pepper
- 6 chicken breast halves (boneless and skinless, 4 oz. each)
- ½ pound bay scallops
- ¼ cup olive oil
- 1- ½ cups sliced fresh mushrooms
- 1 medium onion (to be chopped)
- ¼ cup white wine or chicken broth
- 2 tsp. cornstarch
- ½ cup heavy whipping cream
- 1 tsp. dried tarragon
- ½ cup shredded Swiss cheese

### Instructions

1. Combine the flour, pepper, and salt in a large re-sealable plastic bag.
2. Gradually add chicken and scallops and shake each time to coat.
3. Pour the oil into a large skillet and sauté the chicken and scallops for about 5 minutes until lightly browned. Then, transfer to a greased medium baking dish.
4. Collect the pan drippings to use in sautéing mushrooms and onion. Deglaze using wine or broth and bring to a boil. Continue cooking until liquid is reduced to about 2 tablespoons.
5. Add cornstarch, cream, and tarragon mix thoroughly until well blended. Pour into the skillet and boil. Stir and cook for one additional minute or until thickened. Add spoon over chicken and scallops. Then sprinkle with cheese.
6. Leave open and bake at 375° F hot oven for 18-20 minutes. Serve immediately before the nose completely steals the show.

**Yield:** 4 servings.

**Nutritional content per serving:** Fat: 22 g, Carbs: 14.1 g, Protein: 38 g, Fiber: 1 g.

## Baked Chicken Breasts With Parmesan Crust

Let's bring in the parmesan crust. We are proudly Chinese this time living anywhere in the world since

we are particular about being healthy. However, this is the one you can adopt as your own way of eating your cock.

**Total cook time:** 15 minutes.

*Ingredients*

- 2 tbsps. Dijon mustard
- ½ tsp. thyme leaves (chopped)
- Kosher salt (to taste)
- ¼ tsp. cayenne pepper
- 4 chicken breast halves (about 8 oz. each, boneless, skinless)
- ¾ cup parmesan cheese (freshly grated)
- ¾ cup panko (or dried coarse) baguette breadcrumbs
- Cooking spray

*Instructions*

1. Preheat the oven to 450º F. While mixing the mustard, thyme, ½ teaspoon of salt, and the cayenne in a bowl.
2. Add the breasts and toss to coat completely. Then set aside.
3. Combine the panko and parmesan in a medium shallow bowl. Soak the chicken pieces in the panko mixture, allowing them coated evenly and heavily and absorb the coating by pressing.
4. Set the chicken over a baking sheet on a rack. Add a burst of cooking spray and set the sheet in the middle of the oven. Then bake for 15-20

minutes for the chicken to golden and cook through.

5. Wait 5 minutes before cutting. Then serve; it's yummy but watch your tongue.

*Yield:* 4 servings.

**Nutritional content per serving:** Fat: 14g, Carbs: 8g, Protein: 54g, Fiber: 1g.

## Chicken Burger

As dry as they can be, burgers are among the healthiest meal you can make out of your cock. The dry sensation will fizzle out if your mix allows grated apple and onion to add some moisture to it. Oh, man! This burger will keep your man or woman glued to the dining table.

**Total cook time:** 30 minutes.

*Ingredients*
- 1 large apple (Granny Smith if ok; to be cored and grated)
- ¾ lb. breasts (skinless and boneless, to be minced)
- ½ medium onion (to be finely chopped)
- 2 oz. breadcrumbs
- 1 cloves garlic (to be peeled and minced)
- 1 tsp. chili flakes (optional)
- 1 large handful fresh parsley (to be finely chopped)
- Salt to taste
- Black pepper (freshly ground, to taste)

- 1 ½ tbsps. grapeseed oil

**Instructions**

1. Combine all the ingredients but the oil in a large bowl and mix thoroughly. Divide the mixture into four equal portions and shape with damp hands to about 1 ½-inch thick. Set aside in a place. Cover with cling film and refrigerate for about an hour to firm up.
2. In a non-stick **frying** pan, heat the oil over medium heat. Have the burgers cooked for about 10-12 minutes each side until lightly browned and cooked through all the way.
3. Serve topped with salad on toasted buns. Sliced gherkins, mayo, and ketchup may also be called upon and carried along to applaud the miracle in the dinning.

**Yield:** 4 servings.
**Nutritional content per burger:** Fat: 5.8g, Carbs: 10.9g, Protein: 19.6g, Fiber: 1.8g.

## Healthier Chicken and Leek Pie

You'd crave that creamy chicken pie but you're wary of too many calories. Worry no more. This is recipe is healthier with only 200 calories. Imagine! Still with the superb sumptuousness at that! It's a perfectly easy and healthy dinner when you're feeling overindulged due to the past Christmas! Wondering how? It's the leek that does the magic. Cooking them in a creamy sauce and finishing them off with golden ciabatta breadcrumbs,

you've got the clever and healthier alternative to those f*cking pastry that folks junk around.

**Total cook time:** 40 minutes.

### *Ingredients*

- Spray olive oil
- 2 leeks (to be finely sliced)
- 2 garlic cloves (to be crushed)
- 2 chicken breasts (skinless, to be cubed)
- 1 tbsp. flour
- ½ cup half-fat crème fraîche
- ¾ chicken stock
- 2 ½ oz. ciabatta (to be torn into pieces)
- A small bunch flat-leaf parsley (to be chopped)
- Green beans cooked (to serve)

### *Instructions*

1. Heat the oven to 300° F. Meanwhile, heat a few sprays of olive oil in a skillet.
2. Add the sliced leeks to the skillet and fry for 5 minutes or until softened. Then, add the garlic for a minute. Add the chicken and fry for another 5 minutes.
3. Stir in the flour, then the crème fraîche, and the stock. Season all and bring to a simmer. Cook for 3-4 minutes until the sauce thickens.
4. Blitz the ciabatta in a small food processor to get large breadcrumbs.
5. Stir the parsley and spoon the filling into 4 pie dishes. Scatter it over the breadcrumbs and then bake for 15-20 minutes or until the tops are golden and crisp.

6. Ready to serve, check out how it goes with green beans.

*Yield:* 4 servings.

**Nutritional content per serving:** Fat: 5.8g, Carbs: 16.2g, Protein: 20.9g, Fiber: 3.9g.

# CHAPTER 3: COCK SALADS

## Griddled Chicken With Mustardy Lentil Salad

This is another vibrant way to eat your cock without gluten by the industry standard and your personal standard. The salad with crunchy green beans, lentils, and seasonal mangetout is easy to make and gives you anything but calorie. Try it on a Monday and you will have a happy week.

**Total cook time:** 2 hours.

*Ingredients*

- 3 ½ lb. green beans (trimmed)
- 2 chicken breasts
- 2 tsps. olive oil
- 1 tsp. herbs de Provence
- 1 tin. green lentils (14 oz., to be drained and rinsed)
- A handful mangetout (to be halved)
- 3 oz. mixed baby leaves
- A handful flat-leaf parsley (leaves to be torn)
- 1 tbsp. Dijon mustard
- 1 tbsp. red wine vinegar
- 2 tsps. extra-virgin olive oil

*Instructions*

1. Add salt into the water in a large pan and boil. Add green beans to the boiling salted and cook for no more than a minute. Then add to iced water to refresh. Once cold, drain and cut in half.

2. Set the breasts in-between two pieces of baking paper. Bash to ¼ -inch thickness using a rolling pin.
3. Drizzle with the oil and season and sprinkle with herbs de Provence.
4. Heat a griddle pan on high and add the breast to cook for 4-5 minutes on each side to allow it cook through appearing really charred. Put in a plate and wait 5 minutes before slicing.
5. Combine all the dressing ingredients in a bowl and whisk well with 1 tablespoon of cold water. Add some seasoning and whip. Tip in the lentils with mangetout and green beans. Toss well to mix. Gently add with the salad leaves and parsley.
6. Serve in 3 plates and top with the griddled chicken. Add any resting juices as you wish and it's ready.

**Yield:** 3 servings.
**Nutritional content per serving:** Fat: 6.2g, Carbs: 12.6g, Protein: 30.4g, Fiber: 5.2g.

## Butterflied Rasel Hanout Chicken Breast With Chopped Salad

Let's go to Africa to enjoy some of the African goodies and delicacies. Here's a low-calorie chicken recipe made from North African-inspired recipe. This butterflied chicken ras el hanout is, by the industry standard, gluten-free and yet flavor-full. You've got an easy and quick midweek meal here. Don't forget the dressing and chopped salad, please.

**Total cook time:** 25 minutes.

## Ingredients

- 2 chicken breasts
- Olive oil
- 1 tbsp. ras el hanout

## Ingredients (for dressing)

- 1 tbsp. extra-virgin olive oil
- ½ lemon (to be juiced)
- 1 tbsp. honey
- 1 tsp. sumac

## Ingredients (for chopped salad)

- 2 vine tomatoes (to be chopped)
- ½ cucumber (to be chopped)
- ½ red onion (to be chopped)
- A small bunch flat-leaf parsley (to be torn)

## Instructions

1. Cut each breast along one side from the top down, but not all the way through. Each breast should easily and gradually open like a book.
2. Season well the ras el hanoutin a bowl with 1 tablespoon of oil and toss well to coat.
3. Cook all the chicken breasts for 5 minutes on a griddle or frying pan heated to medium. When one side is dark golden, turn the other side until the breasts are cooked through.
4. Whip all of the dressing ingredients together with some seasoning. Gently stir through the chopped salad and serve with the breast.

*Yields*: 2 servings.

**Nutritional content per serving:** Fat: 14.9g, Carbs: 17.5g, Protein: 39.8g, Fiber: 5.8g.

# Chargrilled Chicken Chimichurri Salad

Here is another juicy chicken goulash recipe glorified with peppery paprika. It's sumptuous if served as simple as it is with one-pot with tagliatelle. Rice can be a good accompaniment for an easy midweek family meal. Don't come near this if you're in search of huge calories for your next Olympic marathon because this dish will give you less than 250 calories. With the added punchy flavors of chimichurri sauce, this chicken salad recipe becomes nicer. You've got another midweek dinner here too.

**Total cook time:** 15 minutes.

*Ingredients*

- 2 small chicken breasts
- 1 tsp. dried oregano
- 1 tsp. dried chili flakes
- olive oil

*Ingredients* **for Chimichurri Salad**

- extra-virgin olive oil
- 1 ½ tbsps. red wine vinegar
- ½ red onion (to be finely diced)
- ½ small garlic clove (to be crushed)
- 2 handfuls rocket
- A small bunch coriander (leaves to be picked)
- A small bunch flat-leaf parsley (leaves to be picked)

*Instructions*
1. Arrange the two chicken breasts between clingfilm. Bash until they are 1-cm thick. Add the bashed breasts to the oregano, chili flakes, some seasoning and 2 teaspoons of olive oil in a bowl.
2. Whisk 1 tablespoon of extra-virgin olive oil with the red wine vinegar together in a bowl. Add some seasoning and whisk. Then add the red onion and garlic.
3. On a griddle pan heated to high, fry the breasts for 4-5 minutes until each side is chargrilled and cooked through.
4. Set aside in a plate for 3 minutes, then slice. Add the coriander, parsley leaves, and rocket to the dressing and toss well.
5. Set onto plates with the sliced chicken and other remaining resting juices as toppings. It's yummy!

*Yield:* 2 Servings.

**Nutritional content per serving:** Fat: 10.5g, Carbs: 3g, Fiber: 36g. Protein: 32.5g.

## Shredded Veg and Chicken Salad With Japanese Sesame Dressing

This book will be doing injustice to you if I didn't drive you on this love trip to Tokyo. Or did you say Yeddo or Tokio? Whatever! The main thing here is that Japanese sesame dressing can give another colorful and flavorful taste to the cock with veggie It's a healthy

chicken salad that is low in calories. Special slightly sweet but tangy edge is provided by the rice vinegar gives together with plenty of crunches you get as a perfect dinner from fresh veg and sesame seeds.

**Total cook time:** 30 minutes.
*Ingredients*
- 2 carrots (to be peeled and shredded)
- 5 oz. chunk white cabbage (to be shredded)
- 3-inch piece cucumber (to be halved, seeded, and shredded)
- 5 radishes (to be shredded)
- 2 tbsps. rice vinegar
- 2 chicken breasts (skinless)
- Sesame oil
- 2 handfuls baby spinach (to be shredded)
- 1 tbsp. black sesame seeds

*Ingredients* **for sesame dressing**
- 2 tbsp. tahini
- I tbsp. mirin
- 1 tbsp. light soy sauce plus a dash for the breasts

*Instructions*
1. In a medium bowl, combine the cabbage, carrots, cucumber, and radishes. Add one tablespoon of rice vinegar and a pinch of salt. Toss all together and set aside.

2. Fill a small with water half full to submerge the chicken breast and boil. Add the breasts to the boiling water. Add a splash of sesame oil and a dash of soy. Return to simmer and cook gently

for about 10 minutes until cooked through. Drain and cool.

3.  Whisk all dressing ingredients together with the rest of rice vinegar and 3-4 tablespoon of water to form a thin dressing.

4.  Slice the breasts and add to the marinating veg with the spinach and dressing. Toss together before serving in 2 plates (be fair and make it equal!) and sprinkle with sesame seeds as finishing and a drizzle of sesame oil.

*Yield*: 2 servings.

**Nutritional content per serving:** Fat: 16.8g, Carbs: 17.8g, Fiber: 9.3g. Protein: 37.9g.

## Holiday Chicken Salad

This is the healthiest recipe if you can't do without eating the cock prepared by you yourself even while holidaying. Yes, outside the comfort of your kitchen, you can still treat your palate as the person that is really in charge. It's just a simple meal with widely available ingredients that you can skillfully put together to produce a healthy yet sumptuous meal.

**Total cook time: 15 minutes.**

*Ingredients*

- 2 cups chicken breasts (cubed, cooked)
- ½ cup mayonnaise
- ½ tsp. paprika
- ¾ cup dried cranberries
- ½ cup celery (chopped)

- 1 green onion (to be chopped)
- ¼ cup green bell pepper (minced)
- 1/3 cup and 2 tbsps. chopped pecans
- ½ tsp. seasoning salt (or to taste)
- Ground black pepper (to taste)

### Instructions

1. Mix mayonnaise with paprika and seasoning salt in a medium bowl.
2. Blend in bell pepper, celery, cranberries, onion, and nuts.
3. Add chopped cooked chicken breast and mix well. Add black pepper as a seasoning to taste.
4. Then chill for 1 hour before serving.
5. Then serve on lettuce cups or make sandwiches.
6. Stand back and relax; enjoy the applause!

**Yield:** 6 servings.

**Nutritional content per serving:** Fat: 23.1g, Carbs: 15.2g, Protein: 13.9g, Fiber: 2g.

## Chicken Satay Noodle Salad

Satay too will die with the cock. This time it's the noodle that'll kill it. Of course, noodles have been inseparable companions of the cock. He feeds on noodles and enjoys it. When it's the time to feed on the cock it's best eaten with noodle as you'll see in this easy chicken satay noodle salad recipe coupled with red cabbage and folks. You'll love to eat this crumby salad again as it's generally healthy and delicious.

**Total cook time:** 1 hour

***Ingredients***

- 2 chicken thighs
- 2 nests rice noodles
- ½ small red cabbage (to be thinly sliced)
- 2 carrots (to be shredded)
- ½ red onion (to be thinly sliced)
- A small bunch mint (leaves to be shredded)
- A handful roasted peanuts (to be roughly chopped)

***Ingredients* (for dressing)**

- 2 tbsps. crunchy peanut butter
- 1 red chili (to be finely chopped)
- A thumb-size piece ginger a thumb-sized (to be grated)
- ½ garlic clove (to be crushed)
- 2 limes (1 to be zested and 1 to be juiced)

***Instructions***

1. Heat the oven to 430º F while seasoning the thighs in a baking tray. Roast in the oven 35 minutes until the skin is crisp and the meat is tender. Take it out of the oven and drain on the kitchen paper. Allow it rest for 10 minutes on a plate and remove the bones. Then shred the meat.
2. Cook the noodles according to pack instructions and then rinse really well with cold water. Drain thoroughly.
3. To prepare the dressing, pour the peanut butter into a bowl and whisk with 3 tablespoons of boiling water. When it loosens, add the chili,

garlic, ginger, lime zest, and juice. Mix again to combine. Toss in the cabbage, carrots, mint, and red onion, and then add the noodles. Toss well.

4. Hey there! Salad is ready, serve in 4 plates and top with the crispy thighs and peanuts.

*Yield:*4 servings.

**Nutritional content per serving:** Fat: 29g, Carbs: 8g, Protein: 45g, Fiber: 2.4g.

# CHAPTER 4: COCK PASTAS

### One-Pot Mediterranean Chicken

It will be unjust to exclude this one-pot Mediterranean chicken thighs recipe from ways of eating cock. Inside just one pot, you can make a delicious and filling dinner from olives, roasted peppers, and orzo with your cock in the Mediterranean style. Your night is less clumsy and so your kitchen as you don't have a lot of cleanups to do. Try this and something different and fanciful and top with whatever you like.

**Total cook time:** 50 minutes.

### *Ingredients*

- 4 chicken thighs (bone-in, skin-on)
- 2 tsps. olive oil
- 1 small onion (to be finely diced)
- 2 cloves garlic (to be minced)
- ½ cup roasted peppers (to be roughly chopped; red, yellow, or orange peppers can go)
- 8 oz. orzo pasta (uncooked)
- ¾ cup kalamata olives (to be halved)
- ½ tsp. dried oregano
- 15 oz. can chickpeas (to be drained and rinsed)
- 3 cups chicken broth
- Kosher salt (to taste)
- Black pepper (to taste)
- 2 tbsps. fresh parsley (to be chopped)

## Instructions

1. Preheat oven to 375º F while thinning oil over medium-high heat in a large skillet or frying pan. Season both sides of the chicken generously with pepper and salt. Then place the chicken in the pan. Cook one side for 4 to 6 minutes or until golden brown and repeat for the other side. Remove the thighs from the skillet.
2. Drain off the excess fat till about 1 teaspoon is left in the skillet. Add the onion and cook for 5 minutes, then garlic and cook for one minute more.
3. Add the oregano, orzo, roasted peppers, kalamata olives, and chickpeas to the pan. Season with ¼ teaspoon of pepper and ½ teaspoon of salt. Place the thighs on top of the orzo mixture and add the chicken broth.
4. Bring everything to boil with the lid on the pot. Place in the oven and bake for 35 minutes for the chicken to be cooked through.
5. It's ready to serve, don't forget parsley as a sprinkle.

*Yield:* 4 servings.

**Nutritional content per serving:** Fat: 20.6g, Carbs: 23.5g, Protein: 20.3g, Fiber: 6.4g.

## Chipotle Chicken and Avocado Flatbreads

Go to bed and do whatever you like with these deliciously sweet cocks. With the smoky flatbreads, the recipe is low in calories but high in protein. Plus, it's very simple to make and also great for an on-the-go lunch. Eating this will make you feel full for longer.

**Total cook time: 30 minutes.**

*Ingredients*

- Chipotle paste
- 2 tsp. cumin seeds
- ½ lemon (to be juiced)
- Olive oil (as needed)
- 4 chicken breasts (skinless)
- 2 red onions (1 ½ to be cut into thin wedges, ½ to be finely chopped)
- 4 small flatbreads
- 4 tbsp. fat-free yogurt
- 1 avocado (to be peeled and stoned)
- 1 large tomato (to be seeded and finely chopped)
- A handful coriander leaves (½ chopped)
- 1 lime (½ to be juiced and ½ wedged)

*Instructions*

1. Heat the oven to 392º F while mixing 2 tablespoons of chipotle paste, cumin seeds, lemon juice, and 2 teaspoons of oil. Pour the mixture over the breasts and onion wedges in a bowl. Roast for 15 minutes in a shallow baking tray and allow the breast cook through and the onions to be tender. Set aside.

2. Sprinkle little water over flatbreads, then wrap them all together using foil. Heat for 5-10 minutes in the oven until soft and warmed through. Now slice the chicken and mix the yogurt with 2 teaspoons of chipotle paste.

3. Mash the avocado using a fork in a bowl and stir in the tomato, lime juice, and chopped

coriander. Allow to mix well. Divide the avocado among the warmed flatbreads. Add the sliced breasts and onion slices.

4. Serve with a spoonful of the yogurt, lime wedges, and a few coriander leaves to your delight.

*Yields*: 4 servings.

**Nutritional content per serving: Fat: 9.3g, Carbs: 49.7g, Protein: 41.3g, Fiber: 4.8g.**

## Garlic Chicken Alfredo

If you've got some zucchini bounty to use, this is a mouth-watering way to go about it. And rush down to a store to pick yours if you haven't grown any. This recipe makes it worth the while of those who made the effort to grow zucchini for their families. Garlic head in the recipe makes the whole thing very garlicky which ends up softening and mellowing the texture and flavor.

**Total cook time:** 30 minutes.

### *Ingredients*
- 1 large zucchini (to be cubed) or 3 - 4 small zucchini
- 1 head garlic
- Hot cooked noodles
- 2 (16 oz.) jars Alfredo sauce
- 8 oz. cream cheese
- ½ lb. mushrooms
- 4 chicken breast halves (boneless skinless, cubed) or 8 boneless skinless chicken thighs

## Instructions

1. Combine well chicken breasts (or thighs), zucchini, mushrooms, and garlic in a baking dish.
2. Sprinkle with the cream cheese cubes and pour the Alfredo sauce on top. Then gently stir to moisten.
3. Bake for 1- ½ hours at 350° F in a preheated oven.
4. Proudly serve hot with cooked noodles. You're a champion.

**Yield:** 4 servings.

**Nutritional content per serving:** Fat: 22.1g, Carbs: 14.1g, Protein: 12.8g, Fiber: 1g.

## Easy Chicken-Mushroom Quesadillas

By now, you should know that the formula mushroom plus chicken can result in extraordinary quesadillas. This healthy recipe provides a conclusive proof to anyone still in doubt.

**Total cook time:** 26 minutes.

## Ingredients

- 1 tbsp. canola oil
- 1 large onion (to be chopped into approximately 2 cups)
- 8 oz. white button mushrooms (about 3 cups)
- 3 cloves garlic (to be minced)
- 2 cups cooked chopped chicken breast (1 breast half, skinless, and boneless)
- 1 tsp. ground cumin

- 1 tsp. chili powder
- 1 tsp. dried oregano
- 2 cups baby spinach leaves (to be sliced into ribbons)
- ½ tsp. salt (or to taste)
- ¼ tsp. black pepper (freshly ground)
- 4 (10-inch) whole-grain flour tortillas
- 1 cup Mexican cheese mix (or Cheddar, to be shredded)
- ½ cup salsa
- ¼ cup reduced-fat sour cream

### *Instructions*

1. Over medium heat, thin the oil in a large skillet and add the onions and mushrooms when hot. Cook for 5-7 minutes until the mushroom is getting dry and brown.
2. Add garlic and cook a minute more.
3. Add chicken, chili powder, cumin, and oregano. Then, stir well for all spices to be incorporated.
4. Add pepper, salt, and spinach, and continue to cook for about 2 minutes until spinach is wilted.
5. Set 1 tortilla on a flat surface and sprinkle with ¼ cup of shredded cheese. Spoon ½ chicken-mushroom mixture on top of the cheese and top with an additional ¼ cup of cheese. Add another flour tortilla as a topping.
6. Spray a large nonstick skillet with cooking spray heat on medium heat. Gently place 1 quesadilla in the skillet and cook for 3 minutes. Carefully flip the quesadilla over using a large spatula and cook for an additional 3 minutes to lightly brown

and for the cheese to melt. Do the same with the second quesadilla.

7. Quarter each quesadilla and serve 2 quarters on a plate topped with 2 tablespoons of salsa and 1 tablespoon of sour cream. It's best enjoyed when the four of you eat together.

*Yield:* 4 servings.

**Nutritional content per serving:** Fat: 16g, Carbs: 46g, Protein: 23g, Fiber: 1g.

# CHAPTER 5: COCK RICE AND NOODLES

## Coconut and Lemongrass Poached Chicken With Lime Rice

This is a complete meal with all you need to make it healthy. The chicken breast in fluffy steamed rice, crisp green vegetables, and aromatic Thai spices will invite you again. Jump inside the warm and exciting bowl of coconut plus lemongrass chicken. All is equal to perfect easy chicken dinner that is low in calories and also free of gluten. You would regret it if you didn't make some extra as your healthy pack at lunch on your next day. This time, we're indeed in Thailand.

**Total cook time:** 30 minutes.

*Ingredients*
- 3 ½ oz. basmati rice
- 1 lime (to be zested and juiced, plus wedges)
- 2 chicken breasts (skinless)
- 1 cup coconut milk (half-fat)
- Chicken stock
- 1 stalk lemongrass (to be bashed and roughly chopped)
- 2 kaffir lime leaves (to be shredded)
- 2 pakchoi (to be trimmed and quartered)
- 3 ½ oz. mangetout (to be trimmed)
- A small handful coriander leaves

## Instructions

1. Tip the rise into 1 cup of water in a small pan after rinsing well. Add a pinch of salt and lime juice. Bring to boil and then lower the heat. Cover to simmer for 10 -12 minutes until the water is completely absorbed. Remove from the heat but keep the lid onto steam.

2. Put the skinless breasts into a snug-fitting pan with the coconut milk and enough chicken stock to submerge. Add the lime leaves and lemongrass and bring to simmer gently. Poach for about 10 minutes for the chicken to be cooked. Then add the pakchoi and mangetout and cook for 2 minutes more.

3. Using a fork, fluff the steamed rice and then stir in all the lime zest and most of the coriander.

4. Strain the chicken and vegetables from the poaching broth. Slice the chicken.

5. It's time to serve the rice between 2 bowls and mount on the breast chicken greens and a spoonful of the poaching liquid. Top with more lime wedges and coriander.

*Yield:* 2 servings

**Nutritional content per serving:** Fat: 9.7g, Carbs: 48.8g, Fiber: 7g. Protein: 42.3g.

## Chicken Madras

This is yet another proof that you can maintain healthy eating and still not miss out on your delicious favorite dishes. Chicken madras will give you just that if you try it out. It's a recipe for a rich and fragrant curry and is a

quick and easy way to feed sweethearts with meals under 300 calories per serving.

**Total cook time:** 1 hour 20 minutes.

*Ingredients*

- 2 onions (to be roughly chopped)
- 2 garlic cloves (to be peeled and chopped)
- Large chunk ginger (to be peeled and sliced)
- 3 green chilies (to be roughly chopped)
- Oil for frying
- 1 ½ lb. chicken thigh fillets (skinless, to be cut into chunks)
- 14 oz.-tin plum tomatoes
- Bunch coriander (to be, chopped)
- Rice (to serve)

*Ingredients* **for spice mix**

- 1 tbsp. coriander seeds
- 1 tsp. cumin seeds
- 1 tsp. fennel seeds
- 2 tsp. fenugreek seeds
- 5 garlic cloves
- 1 tsp. black peppercorns
- 2 small dried red chilies
- Salt to taste

*Instructions*

1. In a dry frying pan, toast all the spices until fragrant. Allow it cool before grinding in a spice grinder.
2. Put the garlic, ginger, chilies, and onion in a small food processor, process to a paste (add a splash of water if needed).

3. Heat 2 tablespoons of oil in a frying pan and fry the paste for about 4 minutes until golden. Add a good pinch of salt. Add the chicken and keep frying. Keep turning in the pan until it is opaque. Add the spices and fry about 3 more minutes.
4. Add a splash of water, if needed and tip in the tomatoes.
5. Bring to a simmer with the cover on and cook for 40 minutes or until the thighs are tender.
6. Stir in the coriander while serving with rice and naan.

*Yield:* 6 servings.

**Nutritional content per serving:** Fat: 7.9g, Carbs: 25.6g, Fiber: 28.3g. Protein: 1.4g.

## Mojito Chicken Wild Rice Salad

You can't have too much salad in so far as health is crucial. Though high on flavor, this chicken salad is low on calories and free of gluten by the industry standards. Mojito chicken with wild rice salad needs no culinary expertise; quite fast and easy to make. If you're thinking about a vibrant fruit and vegetable recipe for your perfect midweek meal, your search stops here.

Total cook time: **30 minutes.**

### *Ingredients*

- 1 lime (plus wedges, to serve)
- A small bunch mint (leaves to be chopped)
- Olive oil

- 1 chicken breast (skinless, bashed to ¾-inch thick)
- 1 ¾ wild rice mix
- ½ small mango (to be stoned and diced)
- 1 spring onion (to be sliced)
- coriander leaves (to be chopped)
- 2 tbsps. red pepper

## Instructions

1. Mix the juice and lime zest with half of the mint and 1 teaspoon of oil. Season and pour over the breast and allow to marinate for at least 30 minutes, or overnight (but in the fridge.)
2. Add the rice into boiling salted water and cook until tender. Drain and rinse thoroughly under cold water. Allow it to cool while cooking the chicken. Meanwhile, heat a grill pan to hot to sear the breasts for 5 minutes on each side or until cooked through.
3. Toss the rice when cool with the coriander, mango, onion, and pepper. Add the rest of the mint. Chop the rind and pith off the remaining lime half into segments. Tip all with the content of the chopping board into the bowl. Season and toss everything together.
4. Slice the breasts and serve. Off it goes with the wild rice salad.

**Yield:** 1 serving.

**Nutritional content per serving:** Fat: 6.1g, Carbs: 64.9g, Fiber: 8.5g. Protein: 40.5g.

# Easy Chicken Mole

This is probably the easiest healthy chicken recipe that is quick to make. (Never mind whatever has been said before).Traditional Mexican mole recipes contain an average of 25 ingredients and a long list of steps. Thus, this easy and quick cock recipe uses a clever cheat, skipping certain unnecessary steps to land on your table flavorful meal under 300 calories in less than an hour. Try it as a midweek dinner.

**Total cook time:** 40 minutes.

### *Ingredients*

- 2 red onions (1 to be chopped, 1 to be sliced into rings)
- 2 garlic cloves (to be crushed)
- olive oil
- 6 chicken thighs (skinless, to be cut into strips)
- Chopped tomatoes (14 oz.-tin)
- 2 cups chicken stock
- ¼ Mexican mole cacao
- A pinch chili powder
- A small bunch coriander (leaves to be picked)
- Cooked rice (to serve)
- Lime wedges (to serve)

### *Instructions*

1. Cook the garlic and chopped onion in 1 tablespoon of olive oil until softened.
2. Add the thighs and fry for 2 minutes. Stir in the tomatoes and stock. Then bring to simmer.
3. Add the chili and mole cacao and cook for 30 minutes more, until thickened.

4. Stir in half of the coriander.
5. Serve on rice with more coriander, lime wedges, and onion rings

*Yield:* 4 servings.

**Nutritional content per serving:** Fat: 11.6 g, Carbs: 9.6 g, Fiber: 2.6 g. Protein: 23.8 g.

## Chicken Coconut Rice

This is similar in several respects to Hawaiian chicken. The Asian fusion is a chicken thigh flavored with a tropical coconut marinade and then grilled to perfection. I'm coming to visit you if you recognize this as a perfect easy dinner option for entertaining.

**Total Cook Time:** 50 minutes.

*Ingredients* **(for chicken)**

- 1 ½ lb. chicken thighs (boneless skinless)
- ½ cup soy sauce (low sodium)
- ¼ cup water
- ¼ cup packed light brown sugar
- ½ tsp. minced garlic
- 1 tsp. sesame oil
- ½ cup light coconut milk
- ¼ cup pineapple juice
- 1 cup pineapple slices (fresh or canned)

*Ingredients* **(for coconut rice)**

- 1 cup white rice (short grain preferable)
- 1 ¼ cup light coconut milk

- ½ cup water
- ¾ tsp. kosher salt
- 2 tsp. brown sugar
- Cilantro leaves and lime wedges (for garnish, optional)

## *Instructions*

1. Combine all the chicken ingredients except the thighs and pineapple slices in a container or re-sealable bag. Seal and marinate the thighs for a minimum of 2 hours and a maximum of 24.
2. On the medium heat, grill the marinated chicken in a grill pan for 6-7 minutes each side or until thighs are cooked through.
3. Add the pineapple to the grill. Cook each side for 2-3 minutes. The pineapple and chicken are ready to serve on a plate awaiting the arrival of the rice(groom).
4. To prepare the rice, boil the coconut milk and water and add salt and rice. With heat reduced to low, cover and cook and simmer for 18 minutes. Add the brown sugar and stir well.
5. Coconut rice is ready to carry the cock thighs and pineapple. Garnish with lime wedges, and cilantro, if desired.

*Yields*: 4 servings.

**Nutritional content per serving:** Fat: 18g, Carbs: 25.2g, Protein: 29.9 g, Fiber: 0.9g.

## Hawaiian Chicken

Take your loved ones to Hawaii through your kitchen and your dining table as you fondle the cock breasts the Hawaiian way and your way. These grilled breasts marinated in a mixture of ginger, ketchup, pineapple juice, and soy sauce will linger in your palate. By the way, a smart cook knows that know that store-bought marinades can be sodium-loaded, sometimes, up to 900mg per 2 tablespoons. Homemade ones guarantee you low sodium and they are the way to go. It's not a big deal to whisk them up with only the ingredients you already have at home.

**Total cook time:** 2 hours 25 minutes.

### *Ingredients*

- ¼ cup pineapple juice
- 2 tbsps. ketchup
- 2 tbsps. lower-sodium soy sauce
- 1 ½ tsps. minced peeled ginger
- 2 garlic cloves (to be minced)
- 4 (6 oz.) chicken breast (to be halved, skinless, boneless)
- Cooking spray (as desired)
- ¾ tsp. salt (to be divided)
- ¼ tsp. black pepper
- 2 cups long-grain white rice
- ¼ cup chopped fresh cilantro

## Instructions

1. Combine the first 5 ingredients and reserve ¼ cup of the marinade while pouring the remainder in a zip-top plastic bag with breasts inside. Then seal and chill for 4 hours.
2. Dry a grill pan to hot over medium-high and coat the pan with cooking spray.
3. Meanwhile, start cooking your rice now. Take the marinated breasts out of the zip-lock bag and discard the remaining marinade. Sprinkle chicken with ½ teaspoon of salt and pepper. Then, add chicken to the pan. Baste one side with 2 tablespoons of the reserved marinade cook 6 minutes. Turn the breast over and repeat the process to the other side of the breast.
4. Combine the cooked rice with ¼ teaspoon salt and cilantro.
5. It's good to feel like visiting the Hawaiian kitchen as you enjoy!

**Yield:** 4 servings.

**Nutritional content per serving:** Fat: 18 g, Carbs: 25.2 g, Protein: 29.9 g, Fiber: 0.9 g.

## Baked Lemon Chicken

Here is another tray packed with chicken thighs accompanied the creamy sauce dexterously made form lemon and fragrant rosemary.

**Total cook time:** 1 hour 20 minutes.

### Ingredients

- 8 whole chicken thighs
- 2 oz. butter

- 2 garlic cloves (to be finely chopped)
- 1 onion  (to be finely chopped)
- 2 leeks (to be finely chopped)
- ½ cup chicken stock
- ½ white wine
- ½ cup double cream
- 2 lemons (1 to be juiced, 1 to be thinly sliced)
- A few whole springs rosemary
- Rice or orzo (to serve)

### Instructions

1. Heat the oven to 400º F. Season the thighs well and arrange in a medium-size roasting tin. Roast for 50 minutes until golden and crisp.
2. In the meantime, melt the butter in a pan and add garlic, onion, and leeks to fry until soft and translucent.
3. Add the chicken stock and wine. Allow to gently simmer for 10 minutes. Then add the lemon juice and double cream. Allow to gently simmer for another 5-10 minutes for the mixture to thicken up.
4. Remove the chicken from the oven and spoon out any fat. Pour the creamy fatty mixture around the thighs. Arrange the slices of lemon around the thighs and scatter over the rosemary sprigs. Set to bake in the oven for yet another 20 minutes.
5. The aroma now should tell you it's ready to serve. Let it go with orzo or rice or anything you choose.

*Yield:* 4 servings.

**Nutritional content per serving:** Fat: 19g, Carbs: 10g, Protein: 50g, Fiber: 1g.

# Lighter Chicken Curry

This is an easy chicken curry recipe with low-fat coconut milk and punchy madras paste as the personal assistant and crunchy sugar snap peas as diet secretary. This flavorsome curry is gluten-free by the industry standard and is low in calories. On dinner you'll try it, it will be one of the unforgettable.

**Total cook time:** 25 minutes.

*Ingredients*

- 2 tbsp. madras curry paste
- 1 medium onion (to be chopped)
- 3 garlic cloves (to be chopped)
- Thumb-Sized piece ginger (to be chopped)
- 3 plum tomatoes (to be chopped)
- 1 tbsp. tomato purée
- 1 ½ cups low-fat coconut milk
- 2 chicken breasts (to be cut into bite-sized pieces)
- ½ lb. basmati rice
- ½ lb. sugar snap peas
- 1 lime (to be juiced, include wedges to serve)
- A handful coriander (to serve)

*Instructions*

- Blend in a food processor the curry paste, garlic, ginger, onion, tomatoes, purée, and some seasoning in a food processor to smoothness.
- Pour into a deep frying pan and cook 10 minutes over medium heat until reduced, thickened, and darkened and fragrant. Add the coconut milk.

- Simmer gently for 10 minutes and add the breast.
- Simmer gently for 10 more minutes for the sauce to thicken and the chicken to cook through.
- Pour the rice into a pan with 1 ½ cups of water and a pinch of salt. Bring to simmer and cover with a lid. Cook gently for 12 minutes until cooked through with all the water absorbed.
- Stir in the sugar snap peas and cook for 2 minutes. Add the lime juice and stir, then a little seasoning. Yum! It's ready to serve with either rice or coriander leaves with lime wedges.

**Yield:** 4 servings.

**Nutritional content per serving:** Fat: 10.6g, Carbs: 50.7g, Protein: 26.2g, Fiber: 4g.

## Healthy Chicken Tikka Burritos

It's time to talk about burritos. Here's another easy and quick cock burrito recipe marinated with tikka marinade. It will add some more value to your ready-made rice and a simple homemade yogurt dip or warmed rotis. This is also a healthy way to eat your cock.

**Total cook time:** 30 minutes.

**Ingredients*

- 4 tbsps. low-fat natural yogurt
- 1 lemon (to be juiced)
- 2 garlic cloves (to be roughly chopped)
- A thumb-sized ginger piece (to be roughly chopped)

- 1 green chili 1 (to be deseeded and roughly chopped)
- ½ a small bunch coriander (finely chopped, stalks and leaves to be kept separate)
- 2 large chicken breasts (skinless, to be cut into bite-sized pieces)
- 1 ½ tsps. smoked paprika
- ¾ tsp. chili powder
- ½ tsp. garam masala
- ½ onion (to be, thinly sliced)
- A small handful cherry tomatoes (to be sliced)
- Uncle Ben's Spicy Pilau Rice (250g pouch)
- 4 rotis (to be warmed)

### Instructions

1. Add half of the yogurt, garlic, ginger, green chili, coriander stalks, and a squeeze of lemon juice in a small food processor and blend until smooth.
2. Tip the mixture into a bowl and add breasts with spices and lots of seasoning. Mix very well and allow to marinate for at least 30 minutes. Share the mixture into 4 metal skewers with gaps between each piece so that they will be well charred.
3. Heat the grill to high and put the skewers onto a foil-lined baking sheet. Grill for about 5 minutes on each side for each side to be charred and cooked through.
4. In the meantime, combine the onion and cherry tomatoes together with a good squeeze of lemon juice. Add some seasoning.

5. Mix together coriander leaves and the remaining yogurt in a bowl. Add a squeeze of lemon juice and a little seasoning with a splash of water to loosen.
6. Cook the rice according to the package instructions and then share it among the 4 rotis. Add a pile of the onion, tomatoes, and chicken. Add the coriander as finishing.
7. It's time to wrap up and serve.

*Yield:* 4 servings.

**Nutritional content per serving:** Fat: 7.9g, Carbs: 52.2g, Fiber: 3g. Protein: 28.7g.

# CHAPTER 6: COCK MAIN DISHES

## KISS Smoked Chicken

Another way to eat your cock leg as tough as it can be is KISS. Well, can't avoid it, you'd KISS the leg before you eat it. But the acronym stands for Keep It Simple and Stupid. If you do that to the fatty, yucky, and dark leg quarters, you don't need a lot of seasonings to make a great meal with the smoke directed to the meat.

**Total cook time:** 1 hour 10 minutes.

*Ingredients*
- Black pepper (to taste)
- 10 lbs. chicken legs with thigh
- Garlic powder (to taste)
- Soaked wood chips (or wood chunks)
- Water
- Seasoning (any of your choice, to taste)
- Salt (to taste)

*Instructions*
1. Soak your wood (which can be chosen from apple, hickory, mesquite, peach, and pecan among others) for about an hour before starting your charcoal fire.
2. Boil a medium bowl of water on the established bed of hot coals. Be careful to avoid splashing your water on the fire to put it off.
3. Set the chicken on the grates with the skin on and allow the steam and fat inside to be heated.

4. Sprinkle or rub the leg with garlic powder, black pepper, and seasoning. You can add salt later but be informed that if the salt is too much, the skin might be hardened and become impossible to cut.
5. Cover your smoker with a lid and leave it there until the cock is ready to be served.
6. Once the meat is set on the grates and the lid is rested on your smoker, toss a handful of soaked wood chips (or wood chunks) to the bed of coals. Periodically check the smoker to be sure that the smoke has a vent.
7. When all smoke has gone out, stir the coals and add a bit of more soaked wood. Repeat the process as often as needed. This will show you how good it is to smoke like a chimney when your chicken is completely smoked.
8. It's time to start KISSing the cock. Enjoy!

**Yield:** 5 servings.

**Nutritional content per serving:** Fat: 10g, Carbs: 52.2g, Fiber: 4 g. Protein: 20.7g.

## Spatchcock Chicken

This is where you have to demonstrate that you are equal to the task of dealing with the hard cock. The ingredients, though few listed here, are rich. You may like to prepare the mixes yourself or buy any brand. C'mon, you'll get pass the sh*t of ordinary cooking with just these three ingredients.

**Total cook time:** 45 minutes.
*Ingredients*

- 1 whole chicken
- ½ cup poultry perfect rub (has a variety of recipes that can be sourced)
- 1 gallon poultry brine (has a variety of recipes that can be sourced)

### Instructions

1. After rinsing the chicken and checking the cavity for giblets and things like that, brine the chicken in a small cooler for 8 hours, topping with a bunch of ice or blue blocks for coolness throughout. (Don't forget to allow the ice melt to dilute the brine.) Then, rinse and pat the chicken dry after 8 hours.
2. With the chicken placed breast down, remove the backbone by cutting through the back of your cock, along the side of the spine, on both sides. You may keep the bone to make a stock or discard it. Then break the breast bones.
3. Apply the poultry perfect rub on both sides of the cock. Place it on a smoker brought to 225°F or on medium-low heat to be grilled for about 4 hours.
4. You can spritz it with Pam about two times toward the end of smoking if you want the cock's skin crispier.
5. It's ready to be served any time you like.

*Yield:* 4 servings.
**Nutritional content per serving:** Fat: 8.9 g, Carbs: 22.3 g, Fiber: 5 g. Protein: 28.3 g.

## Crock-O-Fennel-Cock-A-Doo

If you're fascinated by the crow of the cock you want to eat, you can still hear it! The son of the b*tch will crow in your mouth if you can try out this simple crock-o-fennel-cock-a-doo meal. Carrots can blend with leek to turn the chicken without giblet into a living thing making various scintillating sounds in the palate of your lover.

**Total cook time:** 60 minutes.

### Ingredients

- 3 lbs. chicken (whole, without giblets)
- 1 small fennel bulb
- ½ cup carrots (chopped, big)
- 1 leek (leaves and bulb to be chopped)
- 1 quart water

### Instructions

1. Defrost the chicken if frozen and remove giblets for another dish.
2. Skin the cock as much as possible. Then toss in a crockpot.
3. Wash the fennel and chop the leaves to the desired tenderness.
4. Stack the fennel bulb into the cavity of chicken about ¼ cup of leaves for a chicken.
5. Chop the carrots and leeks. Sprinkle them on the chicken.
6. Pour water (or chicken broth) into the crockpot and fill it to cover the meat.
7. Set on high heat for 30 minutes. Allow it cool and refrigerate.
8. Skim off the fat once to remove all bones.

9. Return the chopped fennel bulb as much as you desire to the pot.
10. Turn the back to the crock and cook on low for 30 minutes.
11. It's now yummy.

*Yield:* 2 servings.

**Nutritional content per serving:** Fat: 9.1 g, Carbs: 23.6 g, Fiber: 3 g. Protein: 29.7 g.

## Chicken Stroganoff

This meal, bequeathed unto Russian by the Stroganoff family, has come to enjoy the worldwide acceptance. The traditional Russian dish of sautéed pieces of your choice served in a sauce with sour cream come in company with mushrooms and egg noodles just like tagliatelle is super yum if the chicken is the meat.

**Total cook time:** 30 minutes.

### *Ingredients*
- 1 lb. chicken breasts (to be thinly sliced)
- 2 oz. plain flour (seasoned with salt and pepper)
- 1 ½ tbsps. grapeseed oil
- 1 medium onion (to be peeled and thinly sliced)
- 1 clove garlic (to be peeled and minced)
- ½ lb. button mushrooms (to be sliced)
- 1 tbsp. Worcestershire sauce
- 1 ¼ cup chicken stock
- 3 tsps. sweet paprika
- Salt and pepper (to taste)
- ¾ cup reduced-fat sour cream
- Handful fresh parsley (to be chopped)

## Instructions

1. Coat each chicken strips lightly in flour, shaking off any excess.
2. Heat the half of oil in a skillet and when hot add the onions to cook for 3-4 minutes or until translucent over medium heat. Increase the heat to and the mushrooms to cook for 3 minutes until tender. Pour in a plate and set aside.
3. Return the skillet to the heat and use the remaining oil to sauté the chicken strips while reducing the heat medium-high. Cook for about 5 minutes or until browned.
4. Pour the onions and mushrooms back to the skillet and add the stock, paprika and Worcestershire sauce. Wait for a couple of minutes as the sauce simmers and thickens. Then add seasonings to taste.
5. Take everything out of the heat and stir in the sour cream. Serve immediately with the parsley sprinkled as a topping. Rice will be begging to have a place in the dish.

*Yield:* 4 servings.

**Nutritional content per serving:** Fat: 11.3 g, Carbs: 16.8 g, Protein: 31.2 g, Fiber: 2.7 g.

# Fred S Green Chile Chicken Enchiladas

Spaniards have different ways of tossing filling around tortilla when it's baked with meat filling and in chilies. However, the unique recipe you have here will create some doubts in the mind of their chef regarding their ability before now. This has been adjusted to the healthy level as the fat content is reduced. Yes, you can enjoy enchilada without fat worries!

**Total cook time:** 1 hour 10 minutes.

*Ingredients*

- 1 can whole green chilies
- 2 tbsps. fresh cilantro
- ½ cup heavy cream (or half-and-half cream)
- 3-4 cups cooked chicken (shredded)
- 5 tomatoes (to be skinned and chopped, optional if there's no time)
- 1 green bell pepper
- 1/8 tsp. cumin
- 1 cup chicken broth
- 2 cans cream of mushroom soup
- 2 tbsps. butter (or margarine)
- 1 medium white onion
- 12 large flour tortillas
- 1 (8 oz.) can of chopped green chilies
- ¾ lb. Monterey jack cheese
- 1-2 cups longhorn cheese (or medium cheddar cheese)
- 1-2 cloves garlic

## Instructions

1. In a large heavy skillet, melt the butter over medium heat. Then, add the onion and garlic.
2. Sauté for about 4 minutes and then add the chilies, cilantro, tomatoes, and bell pepper, broth and cumin.
3. Simmer the mixture over medium-low heat about an hour. Leave uncovered while stirring occasionally. You can add more chicken broth to prevent thickness and dryness if necessary.
4. Take it out of the heat and dip each tortilla in the sauce to soften. After laying them flat, set strips of chicken, 1-2 pieces cheese and 1-2 strips of chilies at one end of the tortilla. After filling, roll the tortilla and place in a greased medium baking dish or pan with the seam-side down.
5. Set the roll tortillas in the pan to fill and pour the sauce over them.
6. Add the soup and cream over all and then cover it with the shredded cheese.
7. Then bake for 30 minutes in the oven preheated to 350 F.
8. Your nose will definitely tell you it's 30 minutes. Then serve hot.

*Yield:* 4 servings.

**Nutritional content per serving:** Fat: 7.3g, Carbs: 8.4g, Protein: 31g, Fiber: 3.78g.

## Spicy Cock

This is what KFC and Mac 'N' Cheese are offering f*cking folks and billing them a great deal. The spicy cock doesn't have a limitation of what you can add or mix. Again, the most important thing is to get out of the box and do it your way. It's a great success story while not compromising your health.

**Total cook time: 45 minutes.**

### *Ingredients*

- 3 tbsps. lemon juice
- ½ cup beer
- ¼ cup soy sauce
- 1 tbsp. brown sugar
- ½ cup chopped fresh parsley
- 1 ½ cups chopped green onions
- 4 tbsps. minced garlic
- ¼ teaspoon black pepper (fresh ground)
- ½ teaspoon cayenne pepper (fresh ground)
- 1 tbsp. chili powder
- 6 chicken breasts (boneless and skinless)
- 4 tbsps. olive oil
- Chives and parsley (as garnishes)

### *Instructions*
1. Cut the breasts into 1-inch slices.

2. Combine black pepper, cayenne pepper, and chili powder in a large bowl and caress the breasts by tossing them around spices until evenly coated.
3. Warm olive oil in a dry frying pan over high heat and position the chicken in hot oil to brown both sides. Then remove the breasts from the pan with the dripping left alone.
4. Add garlic, green onions, and parsley to the pan and cook for 3 minutes. Then add brown sugar, beer, lemon juice, and soy sauce.
5. Bring it to a simmer. Then add chicken breasts back to pan and stir. Now, reduce the heat to medium. Cover for 10 minutes to simmer.
6. Take off the lid and cook for 10 minutes uncovered.
7. Call on the white rice, it's a merry time! Cock and sauce are the cap. Garnish with parsley and chives.

**Yield:** 3 servings.

**Nutritional content per serving:** Fat: 19g, Carbs: 21.3g, Protein: 23.9 g, Fiber: 2.2g.

## Chicken Breast Supreme

This is an award-winning generational dish that is still tantalizing hofmes to date. It actually won in a 1972 recipe contest. Believe this; it worth dishing out for a boyfriend visiting for the first time. The relationship is cemented forever. It goes with any kind of noodles or even rice as a bed under a breast and sauce. You'll always make a double portion because it's sooo nice!

It demonstrates the supremacy of chicken for you to observe.

**Total cook time: 2 hours.**

*Ingredients*
- 6 chicken breast halves (skinless and boneless)
- 1 pinch paprika (or to taste)
- Salt and pepper (to taste)
- 3 tbsps. butter
- 1 (10.75 oz.) can condensed mushroom soup cream
- ⅓ cup milk
- 2 tbsps. minced onion
- ½ cup processed cheese (such as Velveeta, diced)
- 2 tbsps. Worcestershire sauce
- 1 (4 ½ oz.) can sliced mushrooms (to be drained and chopped)
- ⅔ cup sour cream

*Instructions*
1. Preheat oven to 350° F and grease a medium casserole dish.
2. Sprinkle chicken breasts with paprika, pepper, and salt. Meanwhile melt butter in a large skillet. Add the breasts to brown each side for 5 minutes. Then, lay the browned breasts on the prepared casserole dish.
3. Mix the mushroom soup, cheese milk, onion, and Worcestershire sauce in a saucepan and cook over medium-low heat until the cheese

melts. Don't bring to boil. Stir in the sour cream and mix thoroughly until well combined.

4. Pour the mixture over the breasts in the dish. Cover with foil and bake in the preheated oven for 45 minutes until the chicken is tender and the juice runs clear.

5. Open, baste with sauce, and bake 30 more minutes while basting occasionally.

6. The breast is ready to serve warm. Suck with noodles or rice.

*Yield:* 6 servings.
**Nutritional content per serving:** Fat: 20.6g, Carbs: 8.9g, Protein: 28.2g, Fiber: 0.2g.

## Sticky Marmalade and Harissa Chicken

Don't waste your time looking elsewhere for a simpler weeknight dinner of cock than this. Try this recipe and get plenty of sauce to deal with rice or grain to absorb it. It'll also be innovative if you take it through a bitter leaf salad. This harissa chili and spice paste of Middle Eastern origin is indeed a subtle addition to a romantic night.

**Total cook time: 55 minutes.**

*Ingredients*
- 8 chicken thighs
- 100g fine-cut or shredless marmalade
- 1 tsp. dried coriander leaf
- 1 tsp. dried thyme
- 2-3 tbsp. rose harissa
- 1 tbsp. olive oil

## Instructions

1. Heat the oven to 370° F while arranging the thighs in a roasting dish large enough to allow the 8 pieces to fit snugly.
2. Mix the remaining ingredients with some seasoning in a small bowl until well combined.
3. Pour the mixture over the thighs and making sure that the mixture is well licked by each piece.
4. Slide in the oven and bake for 50 minutes for the skin to be crispy and the meat to cook through.
5. After about 5 minutes of baking, serve on top of rice or some other grain with sauce from the dish.

**Yield:** 4 servings.

**Nutritional content per serving:** Fat: 14g, Carbs: 8g, Protein: 54g, Fiber: 1g.

## Oven 'Fried' Chicken and Purple Slaw

You can also eat your cock with the purple slaw while the chicken appears fried. That also will give you sweet dreams. Maybe it's better seen as a Friday night meal.

**Total cook time:** 60 minutes.

### Ingredients

- 3 oz. dried breadcrumbs
- 2 tsps. hot smoked paprika
- ½ tsp. ground turmeric
- 1 tsp. garlic salt
- ½ tsp. celery salt
- 1 tsp. dried oregano

- 2 tbsps. plain flour (well seasoned)
- 1 large egg (to be beaten)
- 4 large chicken thigh fillets (skinless, halved, excess fat removed)
- Oven French fries (for serving)
- Hot sauce (to serve)

**For purple slaw**

- ½ red onion (to be thinly sliced)
- ¼ red cabbage (to be finely shredded)
- 2 carrots (to be shredded)
- 1 tbsp. white wine vinegar
- 2 tbsps. mayonnaise

**Instructions**

1. To prepare the slaw, toss all the vegetables with the vinegar and plenty of seasoning.
2. Coat the breadcrumbs with the paprika, celery, garlic, turmeric, salt, and oregano mixed together in a shallow bowl. Add the flour and egg in 2 separate bowls.
3. Rub the thighs with the flour and egg, and later the spiced breadcrumbs. Set a baking tray over a rack.
4. Heat the oven to 400º F and bake the cock 35-40 minutes to turn crisp, golden and get cooked through.
5. Toss the mayo with the prepared slaw and serve alongside the chicken thigh. Hot and fresh, sumptuous with the hot sauce.

**Yield:** 3 servings.

**Nutritional content per serving:** Fat: 19g, Carbs: 7g, Protein: 28g, Fiber: 0.8g.

# One-Pot Chicken and Quinoa Tagine

Morocco, here we are! Let's taste your stew with one-pot thighs of our cock with Tagine. Hey! Quinoa, come lead the way! I have only one promise for you about this recipe: It's super tasty, super easy, all under 350 calories. Oh, another important guarantee I can give you is this: It's gluten-free, yet comforting.

**Total cook time:** 60 minutes.

## *Ingredients*

- 1 tbsp. vegetable oil
- 4 fillets chicken thigh (skinless)
- I medium onion (to be finely chopped)
- 1 tsp. ground cinnamon
- **1 tsp.** smoked paprika
- 1 tsp. ground coriander
- 1 tsp. ground turmeric
- 1 preserved lemon (flesh to be discarded and rind to be finely chopped)
- 14 oz.-tin chopped tomatoes
- 4 oz. three-color blend quinoa
- A handful dried apricots
- A handful toasted almonds (to serve)
- A small bunch flat-leaf parsley (to be chopped, to serve)

## *Instructions*

1. Thin vegetable oil in a casserole dish over medium heat. Meanwhile, season the thighs generously. Add the seasoned cock thigh to the hot oil in the pan and fry for about 3 minutes, turning until each side is well browned.

2. Add the onion to the pan and cook for about 3 minutes until soft.

3. Stir in all spices and cook for one minute. Then add the preserved lemon and chopped tomatoes. Add half a tin of water and simmer gently for about 15 minutes.

4. Stir in the apricots, quinoa, and add about 2 cups of water. Cook for 25 minutes, stirring occasionally until the quinoa is cooked.

5. Proudly serve with sprinkles of almonds and parsley

*Yield:* 4 servings.

**Nutritional content per serving:** Fat: 11.2 g, Carbs: 27.2 g, Fiber: 5.7 g. Protein: 25.7 g.

## Seared Sriracha Chicken With Pickled Plum Slaw

You can still explore further in your search for a chargrilled chicken recipe. Try and experiment with this seared sriracha chicken with pickled plum slaw. Slaw again? Yes, for a vibrant healthy recipe family of 4 at dinner. Even if you're through with BBQ season, the chargrilled taste of the charcoals can still be a part of your kitchen as you enjoy your cock with this low-calorie dish which is also easy to make.

**Total cook time:** 30 minutes.

*Ingredients*

- 4 chicken thighs (skinless and boneless)
- 2 tbsps. Sriracha chili sauce
- 1 tbsp. runny honey
- 2 tsp. sunflower oil

### Ingredients for slaw

- 1 plum (medium-ripe; to be halved, stoned, and thinly sliced)
- ½ small red onion (to be finely chopped)
- 1 tbsp. rice vinegar
- 1 lime (to be juiced)
- 1 tsp. runny honey
- 1 tsp sesame oil
- 2 tsps. hoisin or plum sauce
- 3 ½ white cabbage (to be finely shredded)
- 1 small raw beetroot (to be peeled and cut into matchsticks)
- 4-inch length cucumber (to be halved and thinly sliced)
- 2 tbsps. cashews (to be toasted)

### Instructions

1. Set the chicken thighs between 2 sheets of clingfilm and flatten to an even thickness using a rolling pin. Whisk the oil, honey, and sriracha together. Add the chicken thighs, toss and allow to marinate for 15 minutes, or refrigerated for a longer marinating.

2. Make slaw by mixing the plum slices, honey, lime juice, onion, sesame oil, vinegar, and hoisin or plum sauce. Season and set aside while the thighs marinate. Meanwhile, mix the beetroot,

cabbage, cashews, and cucumber together in another bowl.

3. Dry and warm a frying pan over medium heat and the thighs to the pan to be fried for about 10 minutes per side until both sides are charred and tender.
4. Tip the plums and dressing over the remaining slaw veg. Mix very well before serving.
5. Let the slaw fondle the breasts as you serve with a little extra sriracha (optional).

**Yield:** 4 servings.

**Nutritional content per serving:** Fat: 20g, Carbs: 28.4g, Fiber: 4.3g. Protein: 28.2g.

## Balsamic Basil Chicken

Here you have a perfect weeknight dinner as you continue your activity. Once you marinate the chicken, every other thing including the veggie or green beans as sides falls into place. It's fitting if you call it a skillet cock dinner win!

**Total cook time:** 45 minutes.

**Ingredients**

- ¼ cup extra-virgin olive oil (to be divided, plus 2 tbsps.)
- 3 tbsps. balsamic vinegar
- 1 tbsp. Dijon mustard
- 2 lb. chicken thighs (bone-in, skin-on)
- Kosher salt
- Black pepper (freshly ground)
- 1 large zucchini (to be cut into half-moons)

- 1 pt. cherry tomatoes (to be halved)
- Freshly grated Parmesan (for serving, optional)
- Basil (as desired, to be thinly sliced)

### Instructions

1. Whisk together ¼ cup of olive oil, mustard, and vinegar in a large bowl. Coat chicken thighs with the mixture by tossing. Cover and store in the fridge for at least 30 minutes but no more than 4 hours.
2. Preheat oven 425° F. Heat the remaining 2 ½ tablespoons of olive oil over medium heat in a medium skillet. Remove the excess marinade from thighs and season with salt and pepper. With skin side down, add to the skillet and cook until golden and sear, usually about 6 minutes. Then flip the thigh and do the same to the other side.
3. Spread tomatoes and zucchini around thighs and season vegetables with pepper and salt. Transfer the skillet to the oven to bake the chicken for about 15 minutes more until it is cooked through.
4. It's time to serve. Oh, wait! Remember to garnish with basil and Parmesan. It will give a better taste to your rice or pasta. You can as well call on green beans as a side.

Yield: 4 servings.

**Nutritional content per serving:** Fat: 13.7g, Carbs: 12.3g, Protein: 47.7g, Fiber: 3.5g.

# Fried Chicken Strips

You'd fondly remember mama's touch on those days! This is what fried chicken strips will do for you. It's a homemade version of our childhood days. It's now improved, finer and better such that it just gives us special feelings as we savor it. Come along, and try your skills on these homemade strips. Let your spouse do it the next time.

**Total cook time:** 55 minutes.

*Ingredients*

- 2 chicken breasts (about 1 ½ lb., boneless and skinless, to be sliced into ½-inch strips)
- 1 ½ cups Italian-seasoned bread crumbs
- 4 large eggs (beaten)
- ½ cup all-purpose flour
- 1 tsp. garlic powder
- Vegetable oil (for frying)

*Instructions*

1. Place breadcrumbs, eggs, and flour each in separate shallow bowls.
2. Whip the garlic powder into eggs in one bowl. In another bowl, season breadcrumbs generously with pepper and salt.
3. Coat strips in flour, dip in egg, breadcrumbs, and back in egg, and then back in breadcrumbs.
4. In a large oven, heat 2-inch deep oil to 325° F. Set a rack over your baking sheet and line with parchment or paper towels.
5. Fry the strips in batches, turning once, until each side golden. Insert an instant-read thermometer into the thickest part of each strip and check the reading. Once it reaches 160° F which takes about 5 minutes, it's ready to serve.

6. Transfer chicken to the prepared rack. Allow it to sit for 5 minutes. Then serve. You'll sing to your mama at your next meeting!

*Yield:* 4 servings.

**Nutritional content per serving:** Fat: 5g, Carbs: 16g, Protein: 20g, Fiber: 3g.

## Peri-peri Chicken Mozzarella Stacks With 'Macho' Peas

Oh my per-peri! So you can do this without gluten. Yes, everything about this easy cock recipe is in a jiffy with creamy mozzarella, punchy 'macho' peas, and roasted red peppers. It's going to be your fans' delight as a lighter version of the restaurant classic. And this particular recipe is gluten-free, so your peri-peri sauce must not bring in gluten.

**Total cook time:** 30 minutes.

### Ingredients

- 2 chicken breasts
- 2 tbsps. peri-peri sauce (plus extra to serve)
- 2 roasted red peppers (from a jar, halved)
- ½ a ball mozzarella (2 ½ oz., to be sliced)
- Dressed rocket (to serve)

### Ingredients for peas

- 2 tsps. olive oil
- ½ onion (to be finely chopped)
- 1 garlic clove (to be finely chopped)
- 3 ½ oz. frozen peas
- ½ red chili (to be finely chopped)
- ½ a small bunch mint (leaves to be shredded)

### Instructions

1. Heat the oven to 398° F. Meanwhile, have a baking sheet lined with foil. Prepare a cutting board where one breast will be chopped ½-inch horizontally using use a knife. This should create two flat and thin chicken pieces. Do the same to the other breast.

2. On a baking tray, season the four chicken pieces and drizzle with peri-peri sauce. Then roast in the oven for 15 minutes for it the breast to cook through.
3. To prepare the peas, heat the oil over medium heat in a frying pan. When hot, add the onion, garlic, and salt. Reduce heat and cook gently 10 minutes to allow it translucent. Add peas and 1 tablespoon of boiling water. Allow it simmer for 3-4 minutes until the peas are lightly cooked. Carefully crush with a fork and sprinkle with the chili and mint. Stir and set aside to keep warm.
4. Then top each chicken piece with a slice of pepper, followed by mozzarella slices. Return it to the oven to cook 5 minutes more until the mozzarella melts.
5. Ready to enjoy! Serve the peas into 2 plates. Stack chicken pieces on one another and serve with dressed rocket for the eyes to send appetite signal.

*Yield:* 2 servings.

Nutritional content per serving: Fat: 13.7g, Carbs: 12.3g, Protein: 47.7g, Fiber: 3.5g.

# CHAPTER 7: COCK DINNER

## Buffalo Chicken Stuffed Spaghetti Squash

Okay, you're trying to cut down on carbs. But you're not on keto anyway. Spaghetti squash will work the miracle. This boat conveys a delicious blend of cheesy, creamy sauce, spaghetti squash, and shredded cock full of flavor. It's easy to make, thus nice for a weeknight dinner. It will always come back to your table!

**Total cook time:** 2 hours.

***Ingredients***

- 1 medium spaghetti squash
- 1 tbsp. vegetable oil
- Kosher salt (to taste)
- Black pepper (freshly ground)
- 2 cups shredded rotisserie chicken
- 1 ½ cups Monterey jack (to be divided)
- ½ cup gorgonzola crumbles
- ½ cup whole milk Greek yogurt
- ½ tsp. garlic powder
- ½ tsp. onion powder
- 1/3 cups hot sauce (plus more for serving)
- Ranch (blue cheese dressing, for serving)
- Celery sticks (for serving)
- Carrot sticks (for serving)

## Instructions

1. Preheat oven to 400° F while drizzling cut sides of spaghetti squash with vegetable oil and seasoning with salt and pepper. Set each half, cut side down on a large foil-lined baking sheet. Now roast for 40 minutes until tender. Allow it to cool a bit and scrape the squash strands into a bowl, using a fork.

2. Next mix the shredded chicken with a cup of Monterey, garlic powder, gorgonzola, yogurt, hot sauce, and onion powder into the bowl with squash. Divide mixture between the hollows inside the squash halves. Sprinkle with the remaining ½ cup of Monterey.

3. Return all to the prepared baking sheet. Continue baking for 25 minutes more, until cheese is bubbling and starts browning in spots.

4. Finally, drizzle the tops with ranch and more hot sauce. Serve hot with celery and carrot sticks, enjoy.

**Yield:** 4 servings.

**Nutritional content per serving:** Fat: 24g, Carbs: 15g, Protein: 38g, Fiber: 2g.

## Paleo Chicken Piccata

The most compelling selling point of this cock recipe is the health aspect of it. It's only 170 calories measured alone. It's a quick and easy-to-make fresh and zesty chicken piccata. It's also paleo-diet friendly and easy to freeze. If you combine it with a green salad, you've got an inviting meal; you need to watch out to avoid

overfeeding. And if it's served with a green salad and cauliflower rice, it's the best healthy dinner of the year.

**Total cook time:** 20 minutes.

### Ingredients

- 2 chicken breasts (skinless)
- Olive oil (as needed)
- 2 tbsps. capers (rinsed)
- 1 garlic (to be crushed)
- 1 lemon (½ to be zested and ½ to be juiced)
- 1 cup chicken stock
- ½ a bunch flat-leaf parsley (to be chopped)
- Green salad and cauliflower rice (to serve)

### Instructions

1. Cut the breasts through the middle lengthwise so that they will open out like a book. Set them between 2 pieces of clingfilm and bash with a rolling pin to 1-cm thick.
2. Heat 1 teaspoon of oil in a frying pan to melt and fry the flattened breasts, each side for 4 minutes until golden, browned and cooked through. Remove from the pan and season. Leave to rest under the foil.
3. Add the capers and garlic, then fry for 1 minute. Add the lemon juice and zest and chicken stock. Simmer for 5 minutes for the sauce to slightly thicken. Return the chicken to the pan with lemon slices and parsley. Then spoon over the sauce.
4. Let it ride on a green salad and cauliflower rice and off it starts going down your throat.

*Yield:* 2 servings.

**Nutritional content per serving:** Fat: 3.2g, Carbs: 1.5g, Protein: 33.7g, Fiber: 1.8g.

## Paprika Chicken Thighs With Cherry Tomatoes, Courgette Ribbons and Mint

Paprika, Tomatoes, Courgette, and mint; imagine the kind of meal you hope to get from the gang up of all that against the cock in your kitchen. Now, what kind of dish your eyes will sight apart from what your nose will report if it's with the courgette ribbons? That's the essence of this crispy and smoky thigh recipe. As easy as this next recipe is, it's very rich in protein and low in calories. All of that you get in less than one hour.

**Total cook time:** 50 minutes.
*Ingredients*
- 4 whole chicken thighs
- 1 tsp. smoked paprika
- 1 tsp. flaky sea salt
- 2 tsps. olive oil
- A large handful cherry tomatoes
- 1 courgette (to be cut into ribbons)
- ½ medium lemon (to be juiced)
- A few leaves mint (to be torn)
- I ½ cup water

*Instructions*
1. In a medium-size bowl, toss the chicken thighs with paprika, salt, and oil. Transfer into a small cold frying pan. Fry for 5-6 minutes or until surely crispy over medium heat. Carefully

remove oil from and fat from the frying pan. Then flip the thighs and pour. Cook for 20 minutes with the heat reduced to low and covered with a lid.

2. Tip the tomatoes into the pan and simmer for 20 minutes more until the thighs are cooked through, turning tender and the tomatoes soften. Meanwhile, pour the courgette ribbons into a bowl immediately you put tomatoes into the pan. Toss with lemon juice and seasoning.

3. Thighs are ready to be served with the tomatoes and juices. Sprinkle the courgette ribbons with mint and decorate the whole show with it.

4. You two lovebirds shouldn't rush, wait for each other as you enjoy.

*Yield:* 2 servings.

**Nutritional content per serving:** Fat: 16.6g, Carbs: 2.5g, Protein: 22.2g, Fiber: 1.8g.

## Thai Mango Chicken

The versatility of cock allows the breast to be sucked with fresh mango as it can be seen on this recipe. Just toss the combination of seared chicken breast and bell peppers with fresh mango in a sweet and savory sauce. You will get the unique Thai dinner from the Asian cuisine made chiefly with chicken with mango. You will get an avalanche of positive reviews from visitors.

**Total cook time:** 30 minutes.

## Ingredients

- 1 tbsp. vegetable oil
- 1 lb. chicken breasts (boneless, skinless, to be cut into 1-inch pieces)
- Salt and pepper (to taste)
- 1 green bell pepper (to be cored, seeded, and thinly sliced)
- 1 red bell pepper ( to be cored, seeded and thinly sliced)
- 1 tsp. minced garlic
- 2 tsps. minced ginger
- 2/3 cup chicken broth
- 2 tbsps. sugar
- 2 tbsps. soy sauce
- 2 tbsps. rice vinegar
- 1 tbsp. cornstarch
- 1 ½ cups fresh mango chunks

## Instructions

1. Over medium heat, thin the oil in a large pan. Once hot, set the chicken in the pan in a single layer or batches. Season with pepper and salt and cook for about 5 minutes or until browned, not dark, and cooked through.
2. Add peppers to the pan and continue cooking for about 5 minutes until softened. Then, add ginger followed by garlic. Cook a minute more.
3. Whisk together the chicken broth, soy sauce, sugar, rice vinegar, and cornstarch in a small bowl. Pour the broth mixture over the breasts

and vegetables. Then bring to a simmer. Cook for about 3 minutes or until sauce thickens.

4. Ready to go; stir in the mango chunks while serving.

*Yield:* 4 servings.

**Nutritional content per serving:** Fat: 6g, Carbs: 20g, Protein: 26g, Fiber: 7g.

## Healthy Chicken Saag

Who says healthy nutritious meals are not sweet? This is another healthy chicken curry recipe. I am not promising you a lot of calories on this recipe also. This recipe is of chicken saag is proof that you can eat your cake and still have it. Yes, you don't have to strike out your favorites on the menu before you eat well on your Friday night. Here's curried cock breast packed with herbs and spices.

**Total cook time:** 45 minutes.

*Ingredients*

- 2 red chilies (to be seeded)
- 2 garlic cloves
- Ginger (4 cm-piece, to be peeled)
- 1 onion (to be chopped)
- Olive oil (or any healthy type)
- 1 tsp. ground cumin
- 1 tsp. ground coriander
- 1 tsp. garam masala
- ½ tsp. turmeric
- 4 cloves
- 4 chicken breasts (skinless, to be cut into large dices)

- 2 oz. red split lentils
- 3 oz. tin chopped tomatoes
- 2 oz. spinach
- 4 small rotis (to be warmed, to serve)
- Water

### Instructions

1. In a small blender, process the chilies, garlic, ginger, and onion to make a paste.
2. Heat 1 teaspoon of oil in a large frying pan and fry the paste for about 2 minutes or until fragrant.
3. Add all spices and cook for one minute more. Add the chicken breasts and toss to coat in the spices. Cook for another 5 minutes then add the lentils and chopped tomatoes. Add 1½ tin of water. Simmer for 25 minutes.
4. Season and then tip in the spinach. Stir well and serve when wilted.

**Yield:** 4 servings.

**Nutritional content per serving:** Fat: 3.8g, Carbs: 27.9g, Fiber: 6.2 g. Protein: 42.8g.

## Chicken Saltimbocca

When Italians say "saltire", you're being invited to take a leap. And when you hear "bocca" in the Italian language, it means into the mouth. Thus, it shouldn't be too tough for you to deduce that the nice touch of a good chef will invite the cock to jump into your mouth when you cook chicken saltimbocca. This Italian dish of veal that is thinly sliced and rolled in prosciutto ham appreciates the help of sage leaves to widen your

appetite. And your night should be filled with sweet dreams after this as your dinner.

**Total cook time:** 30 minutes.

*Ingredients*

- 4 small chicken breasts (skinless and boneless, around 3 ½ oz. each)
- 2 tbsps. plain flour (seasoned with pepper)
- 1 tbsp. grapeseed oil
- 4 thin slices Parma ham
- 4 slices Mozzarella cheese
- 2 tbsps. lemon juice
- 2/3 cup chicken stock
- 1 ½ tbsps. white wine (optional)
- 1 tbsp. unsalted butter (to be cut into cubes)
- 4 fresh sage leaves

*Instructions*

1. Set the breasts between cling film layers, gently flatten them using a rolling pin to about 0.5cm thick.
2. Evenly coat the breasts with the seasoned flour and shake off any excess. Meanwhile, heat oil in a large non-stick skillet over medium-high heat.
3. Add the breasts and fry each side for about 5 minutes or until they are cooked through.
4. Take the skillet off the heat and top the breasts each with a slice of cheese and a slice of ham.
5. Return the skillet to the heat now reduced to low. Cover the skillet with a lid and cook the breasts for about 5 minutes or until the cheese melts. Remove and set on a serving plate.

6. Increase the heat to high and add in the lemon juice, and add the stock and the optional wine. Bring to boil, remove from heat, add butter, and then stir until melted.
7. Serve, topping each breast with a sage leaf and spoon the thickened sauce over each of them.
8. It's time to observe how the saltimbocca summersaults and leaps into your mouth and remains there including your love.

*Yield:* 4 servings.

**Nutritional content per serving:** Fat: 13.3 g, Carbs: 0.48 g, Protein: 13.3 g, Fiber: 0.48 g.

## S. and S. Style Chicken

There is some sort of uniqueness in the S. and S. style of preparing cock. But I need to tell you that you don't need the trip to Oshawa in Ontario or to Toronto to make an order before you can treat yourself to such a nice meal. The secret of the Canadian chef is right here. The intent is to serve you a happy dinner.

**Total cook time:** 1 hour.

*Ingredients*
- 1 package fresh baby spinach
- 3 tbsps. bacon bits
- 2 tsp. minced garlic
- 3. tbsps. honey
- 3 tbsps. Dijon mustard
- 1 container baby Bella mushrooms (sliced)
- 1 small onion (to be chopped or diced)
- 2 cups balsamic vinegar
- Italian parsley (as desired)

- Olive oil (as desired)
- 1 lemon
- 4 chicken breasts (boneless, skinless)
- Salt and pepper (to taste)

### Instructions

1. Sprinkle salt and pepper on the breast. Squeeze the lemon over the breasts.
2. In the meantime, warm the olive oil over medium heat. Place the breasts in the hot olive oil. Without moving things around, sear on both sides, until golden brown, about 3-5 minutes. Then, remove from the pan and place in a baking dish. Reduce heat.
3. Deglaze by adding vinegar to the pan and scrape the brown bits with a spatula. Over low heat, allow to cook for about 3 minutes and take off the heat.
4. Add the onion, then mushrooms to the vinegar. Cook, stirring occasionally until onions and mushrooms are soft. Then, add garlic, honey, and mustard, and bacon bits. Stir well to combine.
5. Pour the mixture over the cock in a dish and cover with foil. Cook in 350°F hot oven for 30-40 minutes. About 5 or 10 minutes to the end of the oven time, uncover the chicken.
6. Serve on 4 plates garnished with fresh spinach and top with sauce over both chicken and spinach. Also, sprinkle with parsley.

*Yield:* 4 servings.

**Nutritional content per serving:** Fat: 10g, Carbs: 6.4g, Protein: 29g, Fiber: 3.7g.

# <u>CONCLUSION</u>

So the more important question now is, 'how would you love to eat your cock'? If you're doing it for her, how would you like her to eat your cock? And if for him, how? Remember, you're not limited by the sh*t called "standard", "normal" "traditional" cooking. You should rather be concerned about the health implication of whatever you're doing and how your food complements your health. And that's what this book is all about; taking your culinary skills out of the ordinary to the weird world yet within the healthy range.

Each time you feel chicken, you're not condemned to take your spouse to KFC! Your brand is made in your chicken kitchen or even in your cock bed. Tantalize 'em and let him cry fowl (or foul) when there is one. Challenge the chef and waiters that and boast that you have done it yourself and your way.

Get out of this world and the woods with your soups, sauces, fries, burger, satay, enchiladas, burritos, and even salads. All of these and many more are what you can do with your cock. Japanese, Chinese, Italian, and Russian cuisines, to mention a few are also explored to show you the rooster's versatility when you feed him with curry, carrot, leeks, garlic, thymes, berries, and assorted ingredients.

Make sure your kitchen is close when next you are doing it your way so that your secret of nice tantalizing,

lovely cooking is not leaked and lest you start to moan 'my husband is having an affair.'

Always have a merry meal.

.